Elizabeth,

One of the most well read women I know.
Merry Christmas 2015
xxoo
Mom

WELL-READ WOMEN

WELL-READ WOMEN

PORTRAITS OF FICTION'S MOST BELOVED HEROINES

by Samantha Hahn

CHRONICLE BOOKS

SAN FRANCISCO

A portion of this book's proceeds are donated to A Room to Read,
a charity that supports literacy and gender equality in education.

...

Introduction and illustrations copyright © 2013 by Samantha Hahn.
All rights reserved. No part of this book may be reproduced in any
form without written permission from the publisher.

Page 108 constitutes a continuation of the copyright page.

Library of Congress Cataloging-in-Publication Data available.

ISBN: 978-1-4521-1415-6

Manufactured in China.

Design by Kristen Hewitt

10 9 8 7 6 5 4 3

Chronicle Books LLC
680 Second Street
San Francisco, CA 94107
www.chroniclebooks.com

In loving memory of my dad, Lewis Hahn

INTRODUCTION

Anna Karenina, Daisy Buchanan, Jane Eyre: the greatest female characters inflame our passions and excite our imaginations. Our favorite characters are universal archetypes and uniquely flawed individuals all at once. Every so often, an author creates this kind of masterpiece, a female figure of such dazzling originality and truth that she will resonate with readers for all time. We sympathize with her, we admire her, we hate her, we want to be her. Ultimately, every reader brings his or her own imagination to the task of envisioning these legendary characters.

As an artist consumed by the female form, I could not resist the challenge of bringing each of the greatest women in literature (in my own opinion, of course) to life, as, reading intently, I see them spring forth in my mind.

To choose the characters I portrayed in this book, I cast my net across the Western canon and a bit beyond. Some of these stories were new to me, and some were treasured favorites. They come from novels, plays, and poetry, and each is, in her own way, profound. Every reader conjures her own vision. No two Scarletts or Lolitas are alike. Seeking reference for them was a thrill and an adventure. It was my goal to evoke the magic and intrigue of an era through little details like the style of Clarissa Dalloway's Jazz Age turban and Becky Sharp's Edwardian dress. Beyond the surface details, it was essential to me to capture the feeling of each character, to visually interpret her through my emotional lens, to portray her as I see her in my mind's eye. From Edna Pontellier's despondent eyes to Wendy Darling's warm smile, I set out to convey the essence of each one as we feel her through the author's description of her and her world. I illustrated quotes from their dialogue or thoughts, giving them voice as well as presence.

Each of these characters is now as familiar to me as a close friend. I learned so much about myself from getting to know each of them. I invite you into this book as though you, too, are in the scene the author created. Meet these heroines, befriend them, and in the process, perhaps, learn about yourself. Whether you've read some or all of these stories, I hope you enjoy gazing into the eyes of all of the powerful, damaged, beautiful, and incandescent women in my book. I hope you follow them back to their original stories and come to see them in your own way, too.

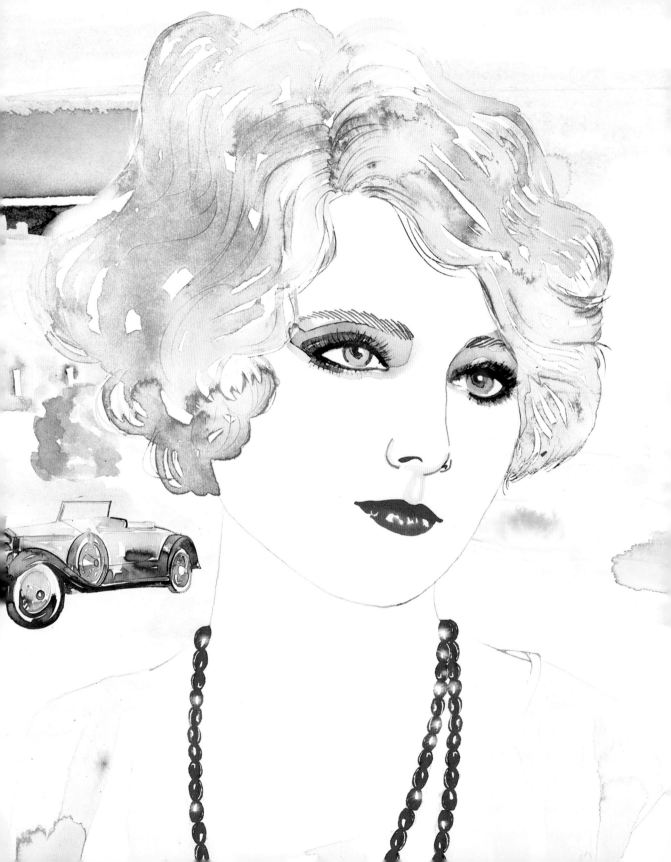

ALL RIGHT... I'M GLAD IT'S A GIRL.
AND I HOPE SHE'LL BE A FOOL—
THAT'S THE BEST THING A GIRL CAN BE
IN THIS WORLD,

A BEAUTIFUL LITTLE FOOL.

DAISY BUCHANAN

The Great Gatsby by F. Scott Fitzgerald

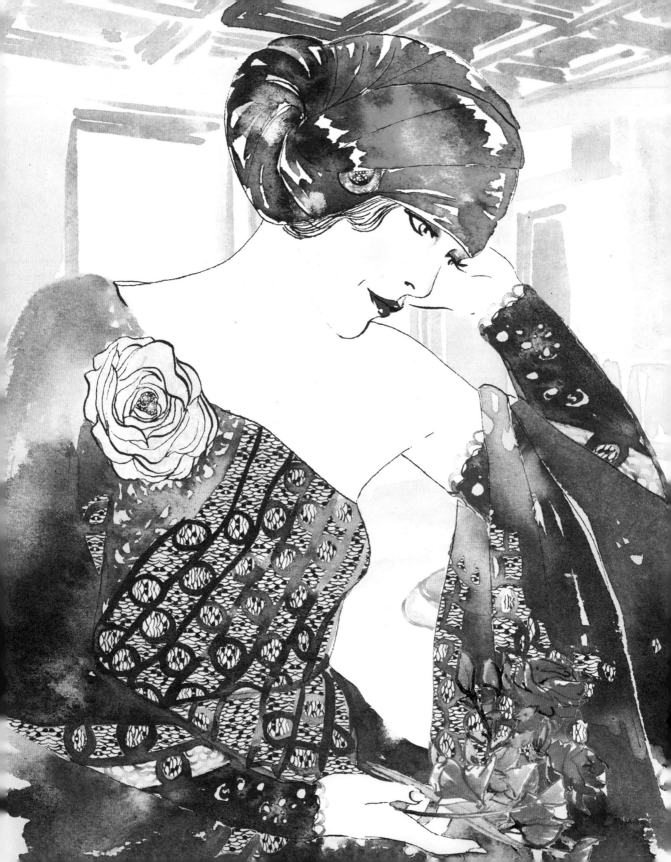

what a morning—
fresh as if issued
to children on a beach.

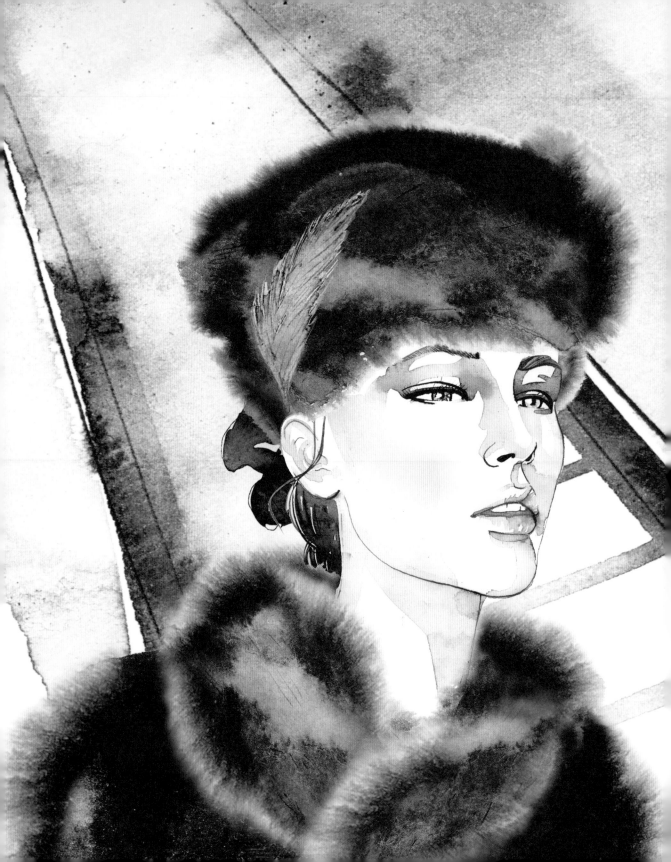

Haven't I striven,
striven with all my strength,
to find something
to give meaning to my life?

ANNA KARENINA

Anna Karenina by Leo Tolstoy

13

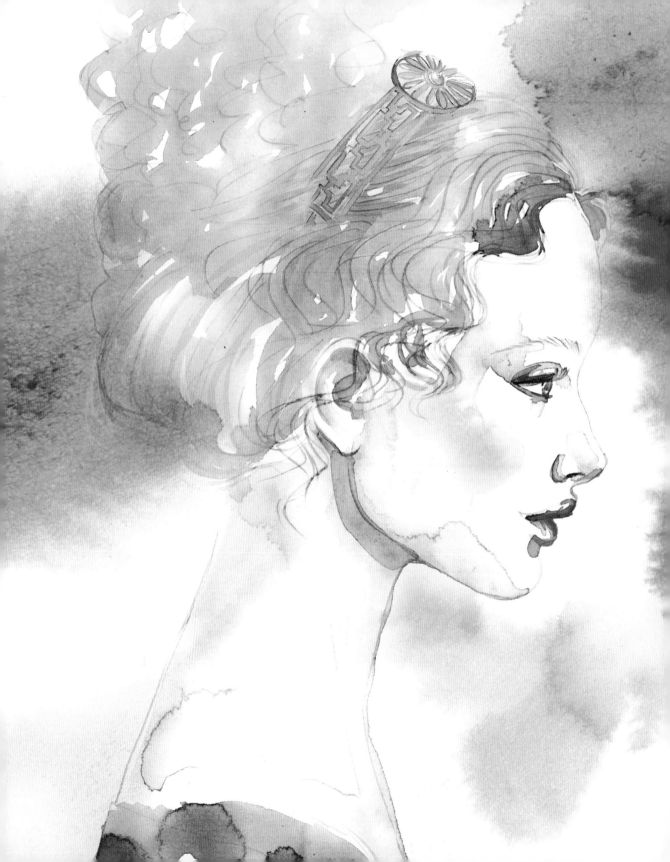

This sensation of listlessness, weariness, stupidity,

this disinclination to sit down

and employ myself,

this feeling of every thing's being dull and insipid about the house!

I must be in love;

I should be the oddest creature in the world

if I were not—

for a few weeks at least.

EMMA WOODHOUSE

Emma by Jane Austen

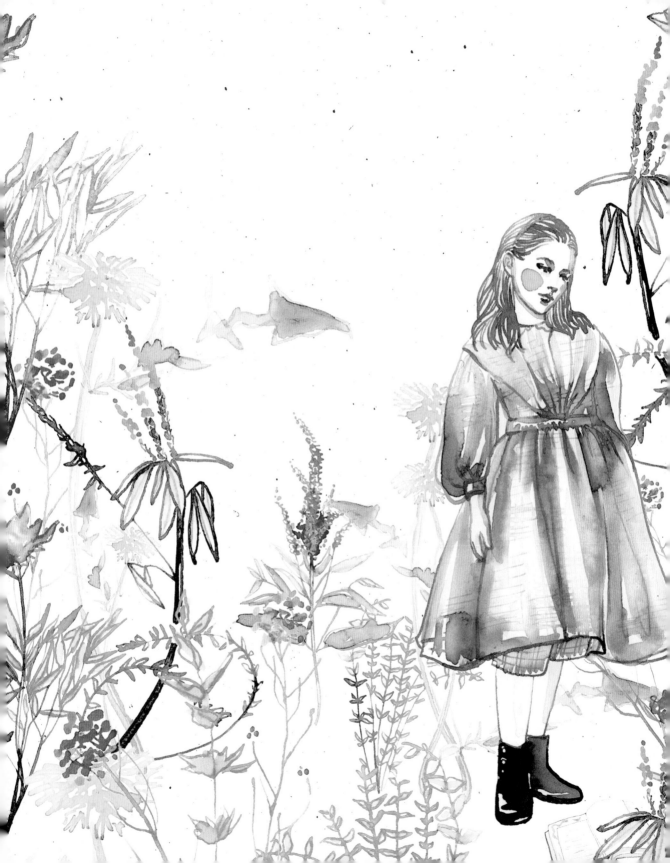

I wonder if I've been changed in the night?

Let me think: was I the same when I got up this morning?

I almost think I can remember feeling a little different.

But if I'm not the same, the next question is

"Who in the world am I?"

ALICE
Alice's Adventures in Wonderland by Lewis Carroll

I have never allowed a gentleman to dictate to me, or to interfere with anything I do.

Daisy Miller by Henry James

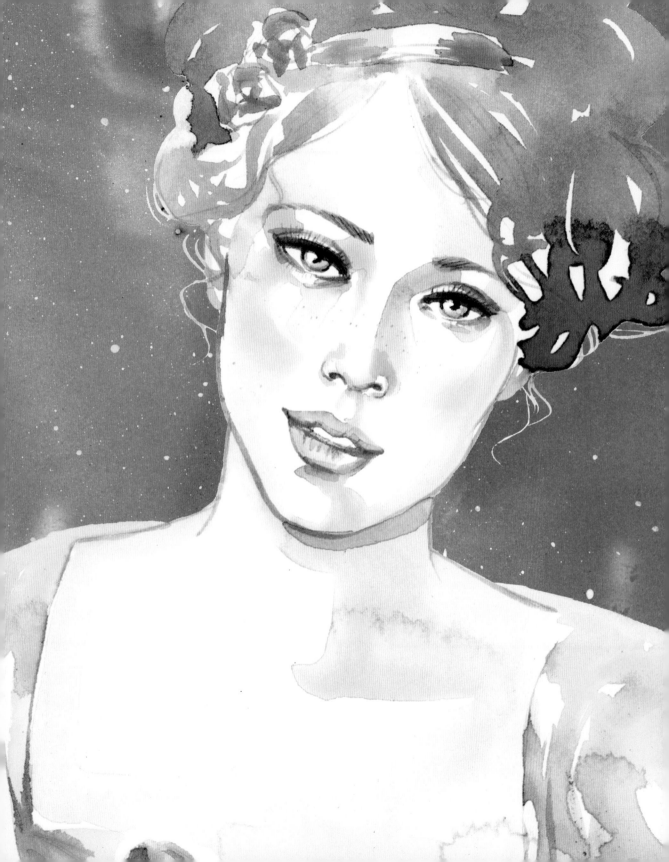

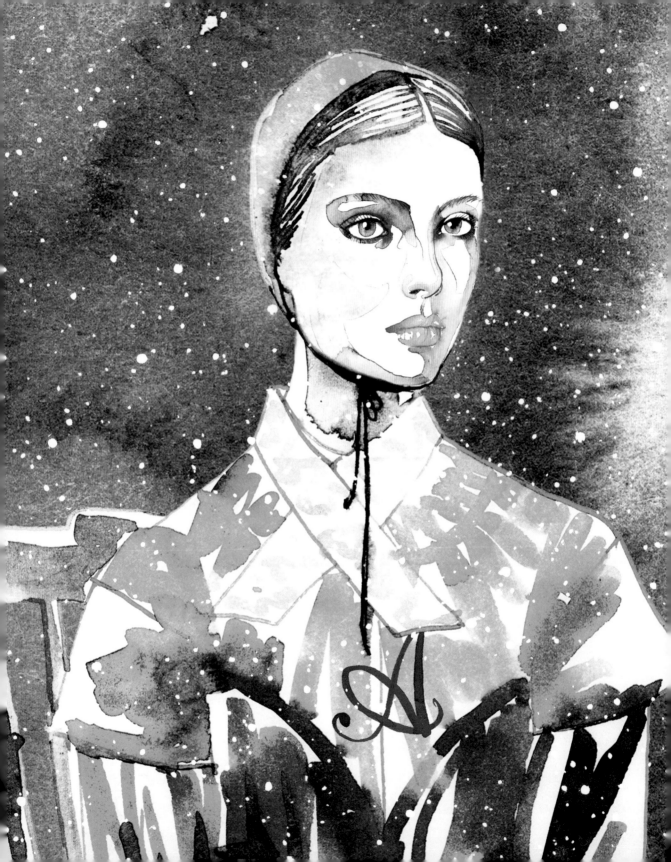

Thou must gather thine own sunshine. I have none to give thee!

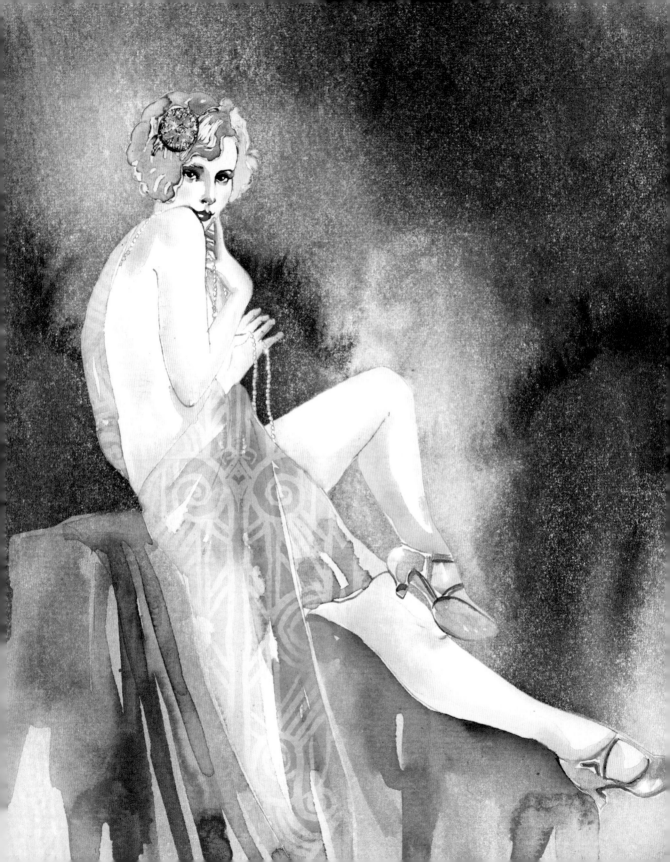

it is quite an easy thing to pretend not to see one gentleman,

but it is a quite hard thing to pretend not to see two gentlemen.

LORELEI LEE

Gentlemen Prefer Blondes by Anita Loos

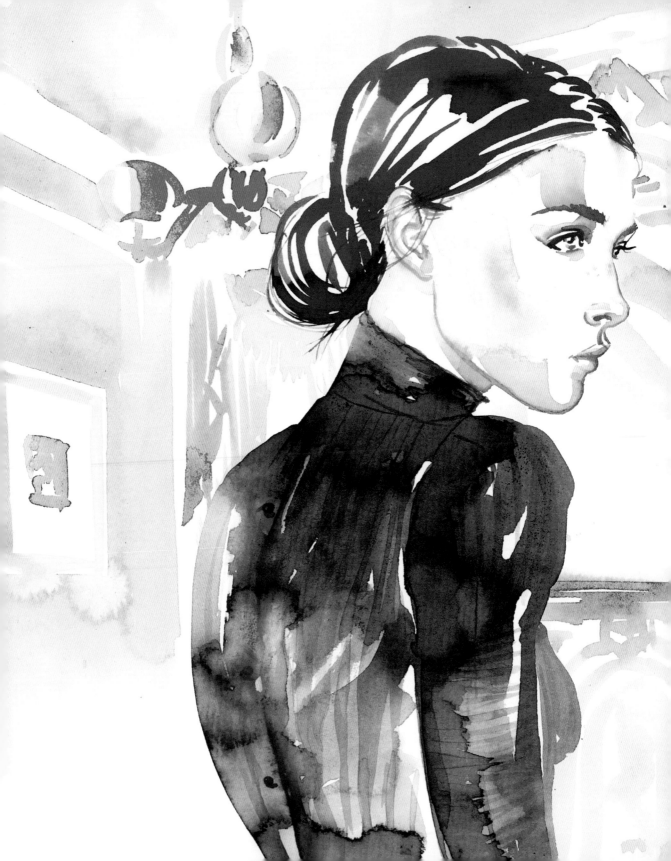

If I'm ever to reach any understanding
of myself and the things around me,
I must learn to stand alone.

NORA HELMER
A Doll's House by Henrik Ibsen

I would give up the unessential;
I would give my money,
I would give my life for my children;
but I wouldn't give myself.

EDNA PONTELLIER
The Awakening by Kate Chopin

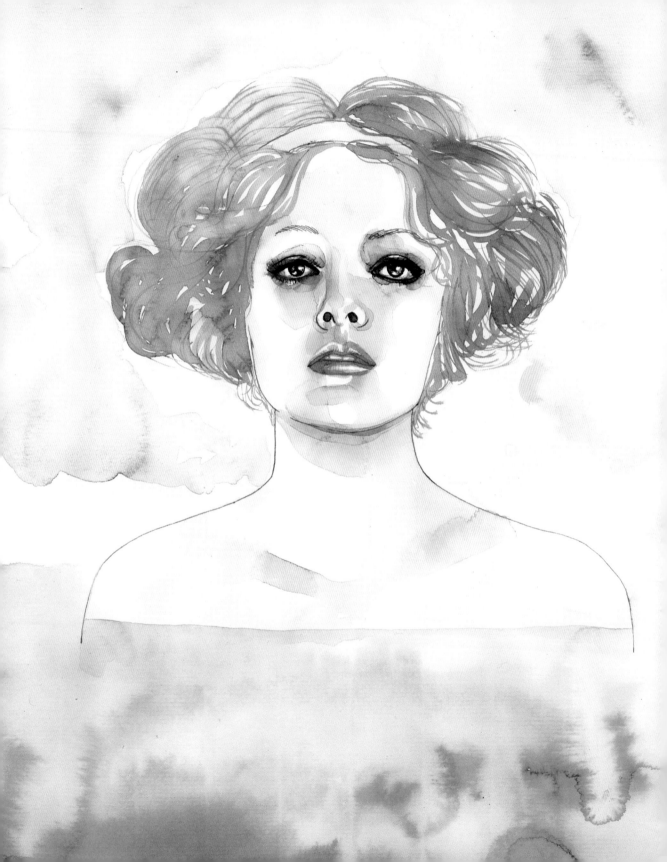

Laws and principles

are not for the times

when there is no temptation...

JANE EYRE

Jane Eyre by Charlotte Brontë

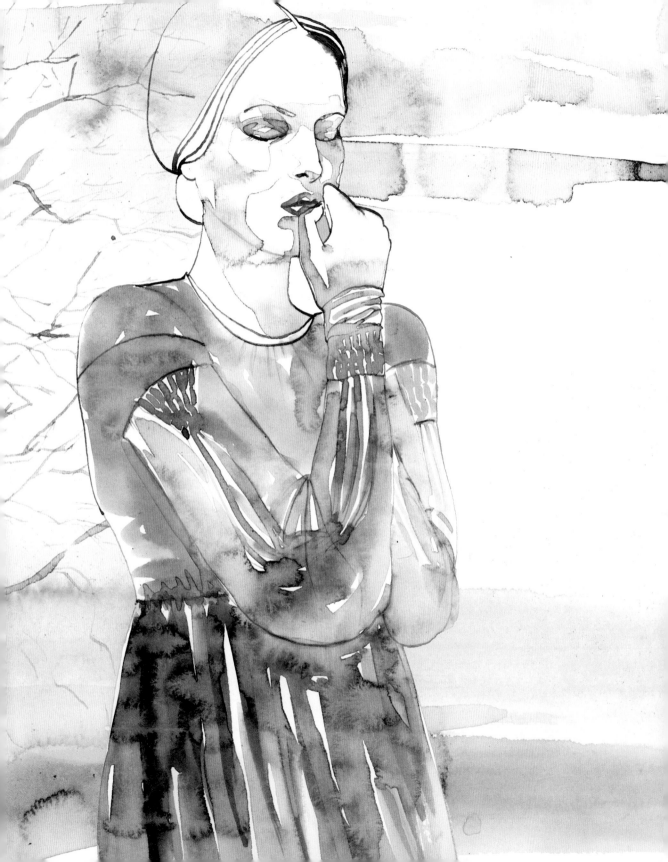

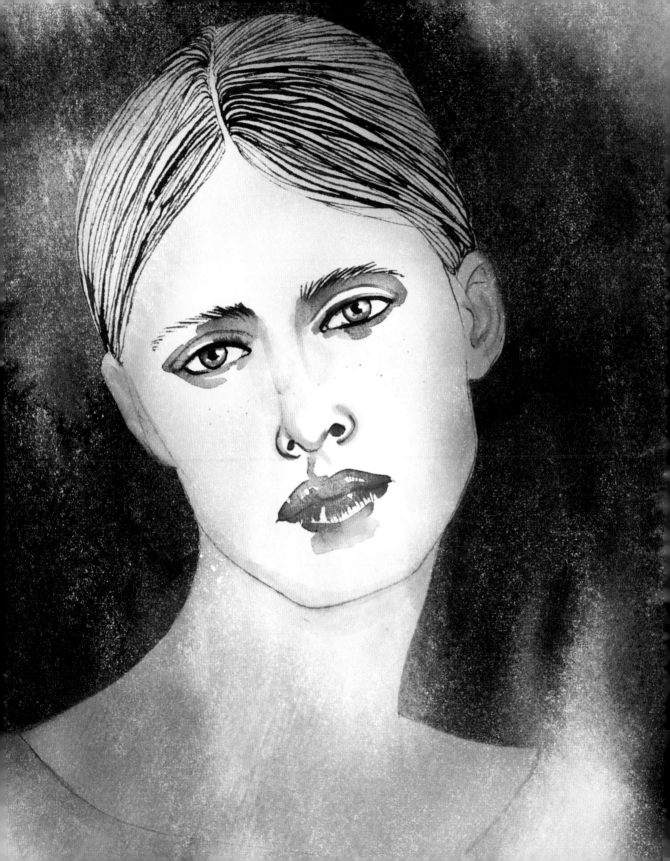

Oh, do not move!
do not speak!
look at me!
Something so sweet
comes from
your eyes
that helps me
so much!

EMMA BOVARY

Madame Bovary by Gustave Flaubert

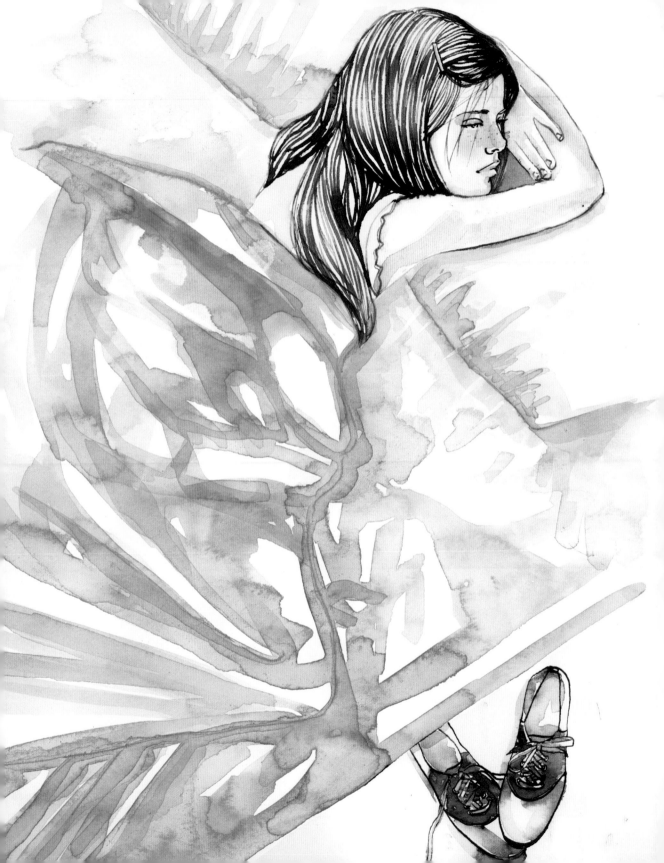

I was a daisy-fresh girl,

and look what you've done to me.

DOLORES HAZE
Lolita by Vladimir Nabokov

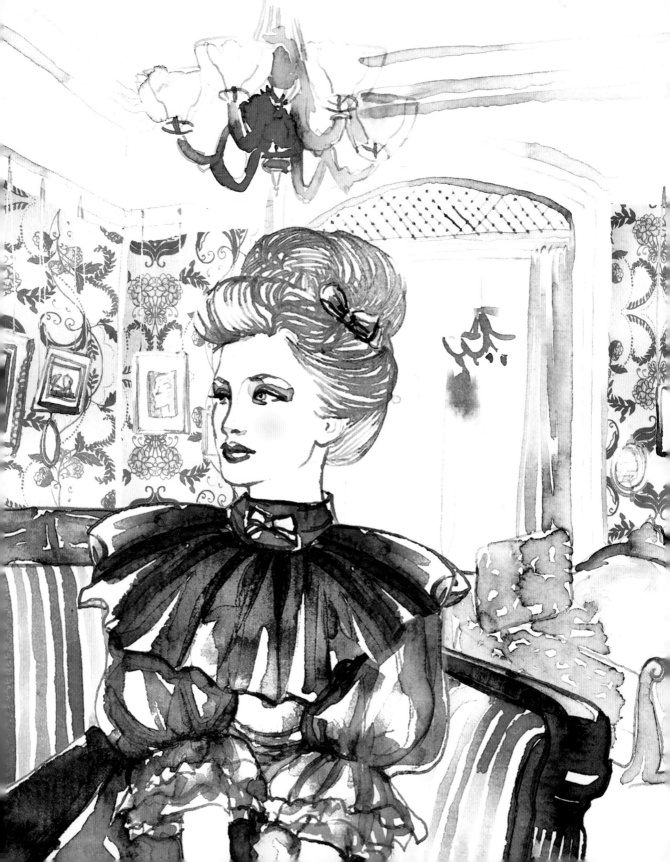

You think we live *on* the rich,

rather than with them:

and so we do, in a sense ~

but it's a privilege

we have to pay for!

LILY BART

The House of Mirth by Edith Wharton

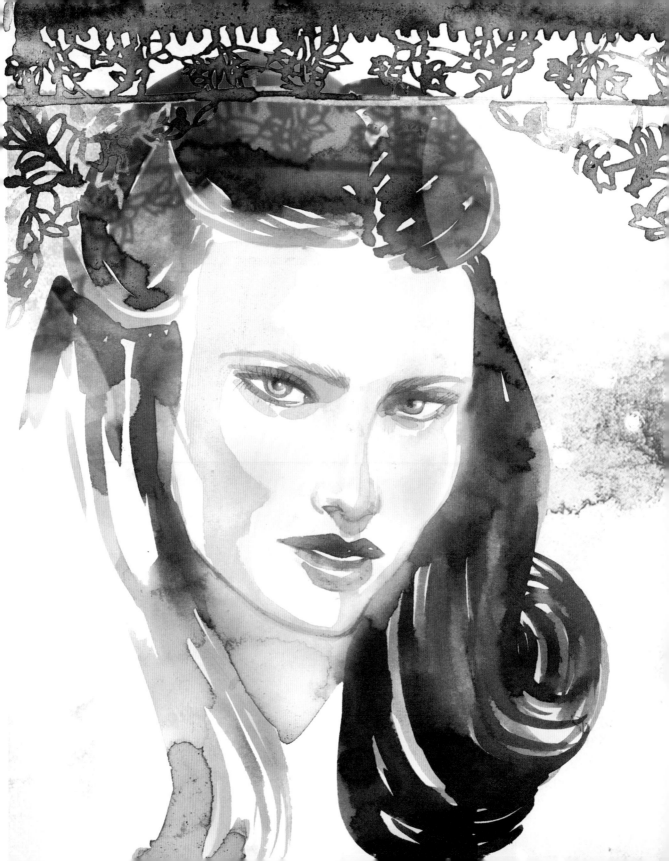

You know as well as I do
that a single girl, a girl alone
in the world, has got to keep a firm hold
on her emotions or
she'll be lost!

BLANCHE DUBOIS

A Streetcar Named Desire by Tennessee Williams

Children are unconstrainedly sincere
and not ashamed of the truth,
while we, from fear of seeming backward,
are ready to betray what's most dear,
to praise the repulsive,
and to say yes to the incomprehensible.

LARA GUISHAR
Doctor Zhivago by Boris Pasternak

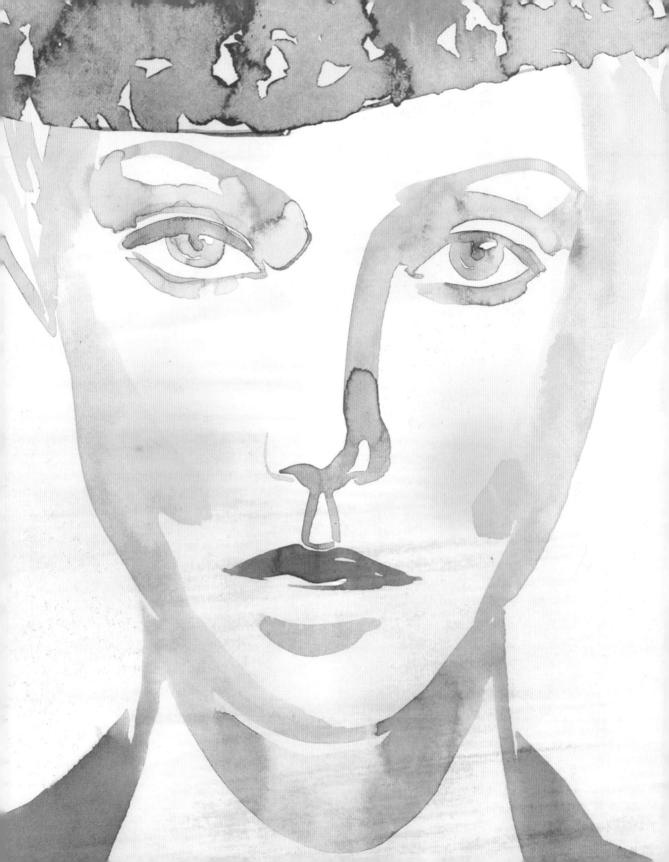

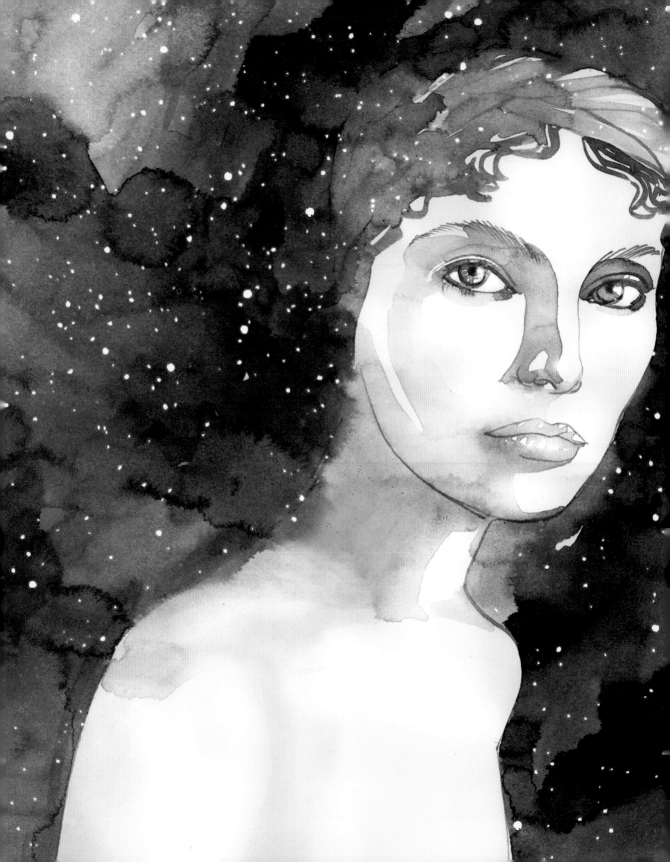

My nature is for mutual love, not hate.

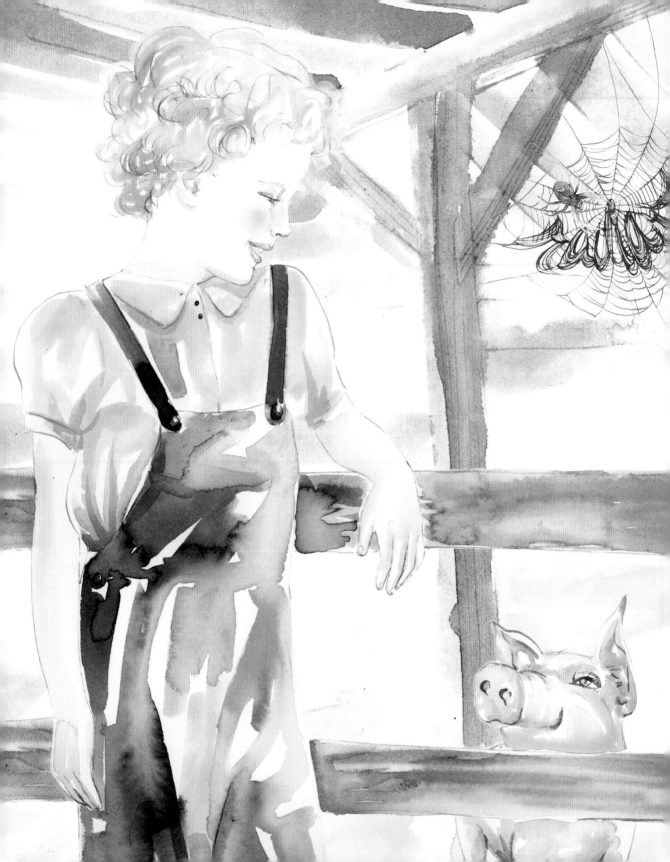

You have been my friend.

That in itself is a tremendous thing.

CHARLOTTE A. CAVATICA
Charlotte's Web by E. B. White

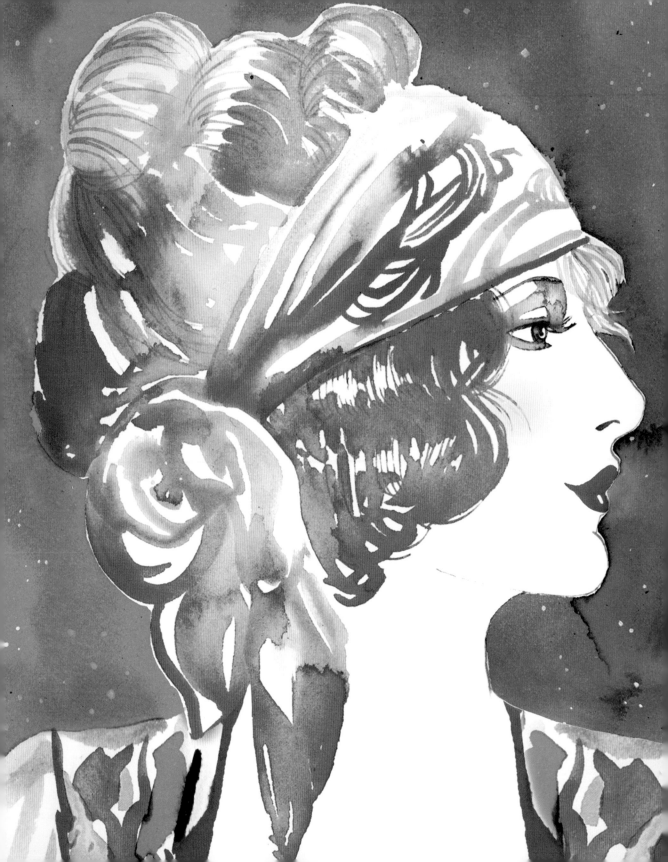

I love you, Nicky, because you smell nice and know such fascinating people.

NORA CHARLES

The Thin Man by Dashiell Hammett

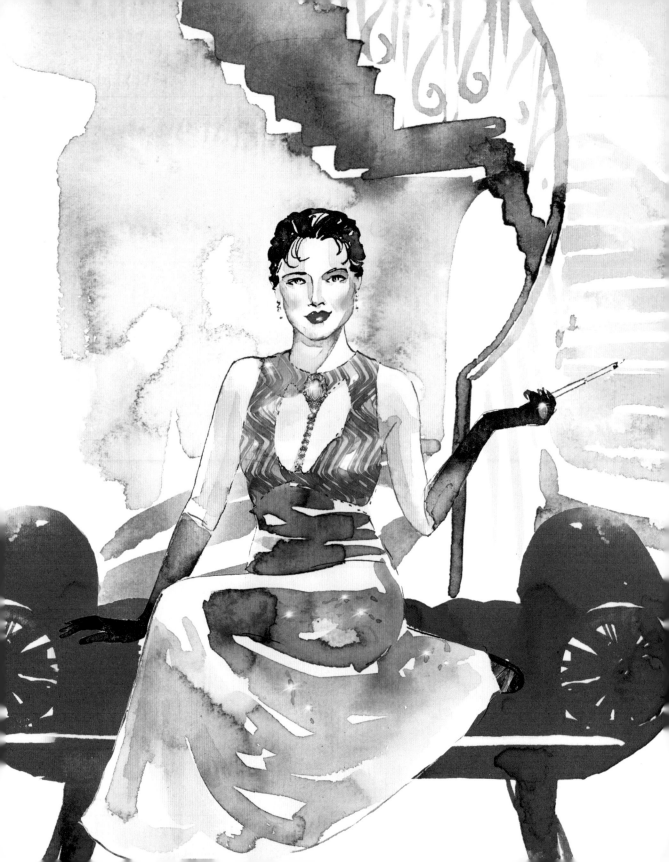

Don't ask me to explain anything until I've had a drink.

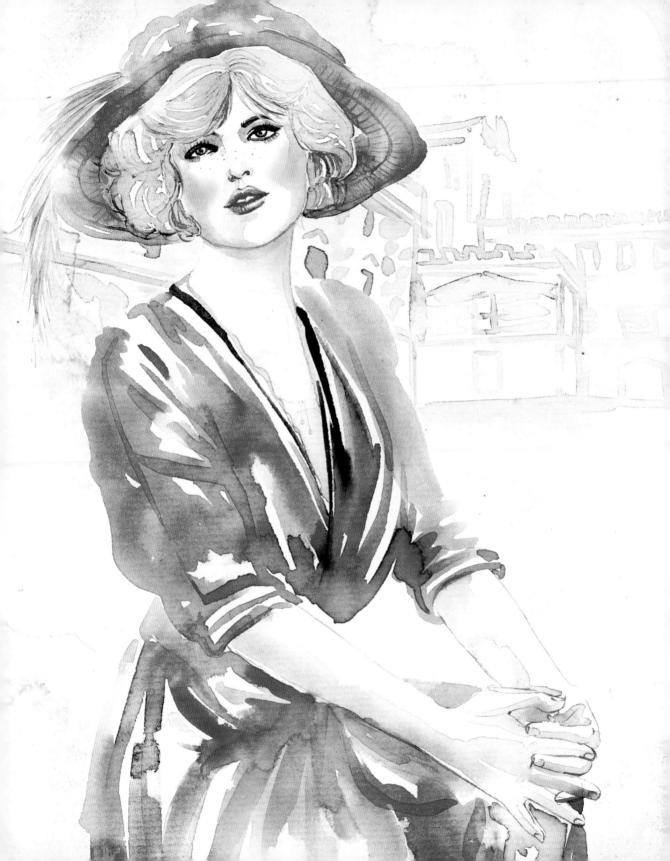

you don't know all I have to suffer and bear in silence.

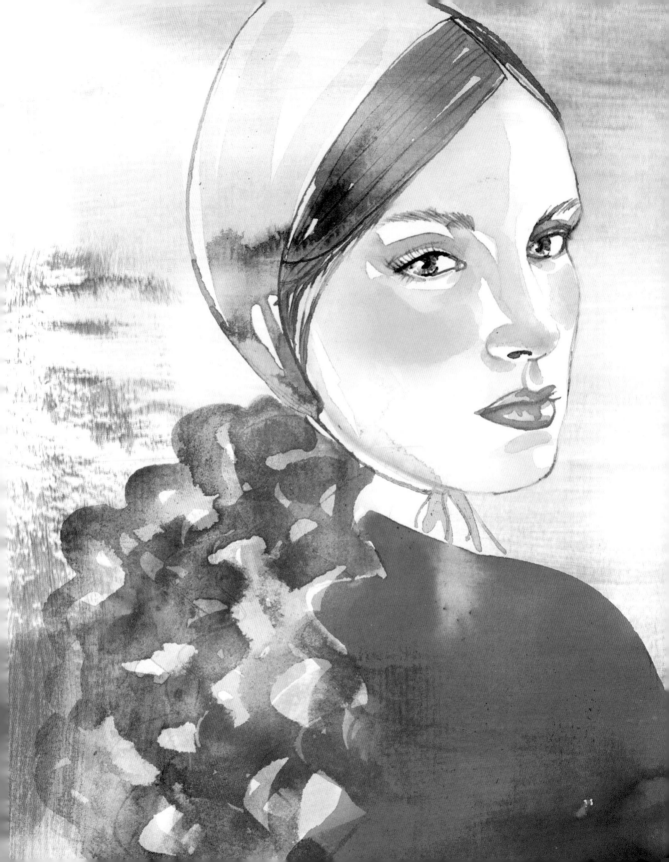

As covetousness is the root of all evil,
so poverty is, I believe,
the worst of all snares.

MOLL FLANDERS

The Fortunes and Misfortunes of the Famous Moll Flanders by Daniel Defoe

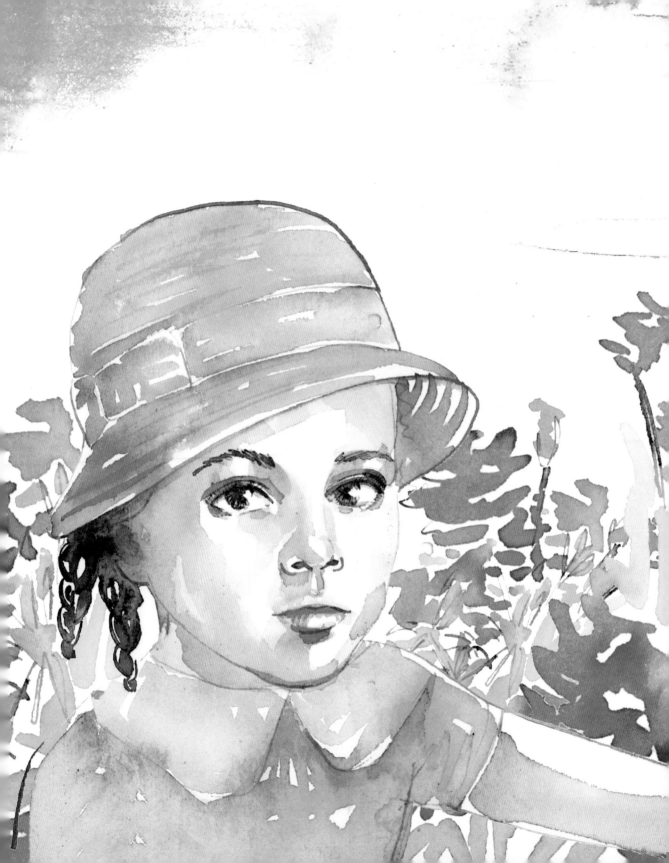

Why, look at pretty-eyed Pecola.
We mustn't do bad things in front of
those pretty eyes.

PECOLA

The Bluest Eye by Toni Morrison

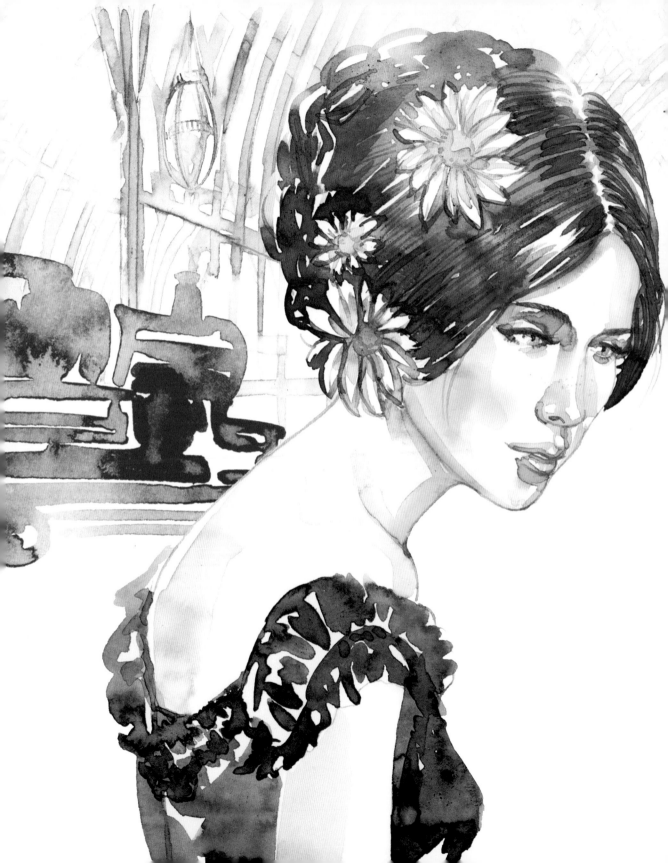

You see my ignorance, my blunders, the way I wander about as if the world belonged to me, simply because—because it has been put in my power to do so.

ISABEL ARCHER

The Portrait of a Lady by Henry James

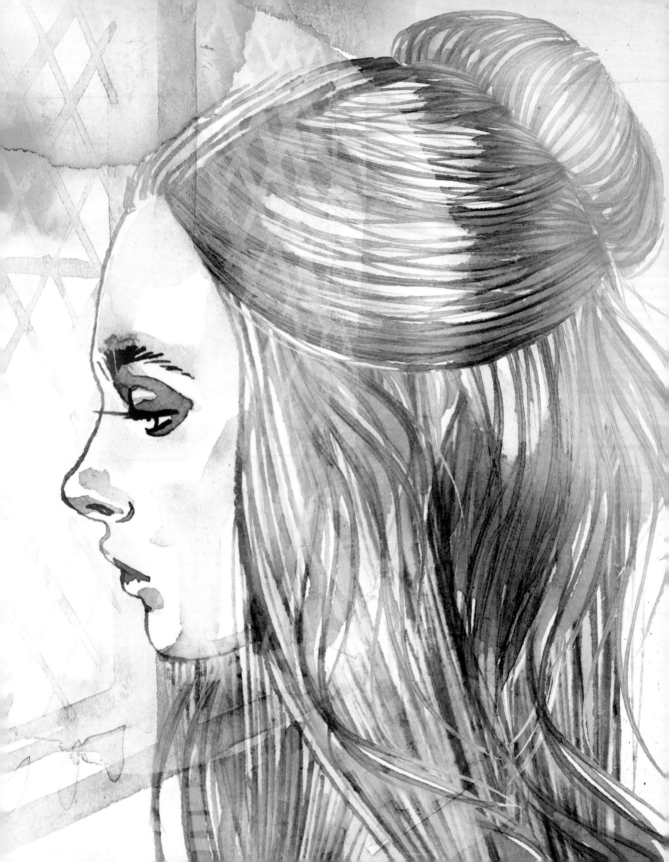

*Whatever our souls are made of,
his and mine are the same.*

CATHERINE EARNSHAW
Wuthering Heights by Emily Brontë

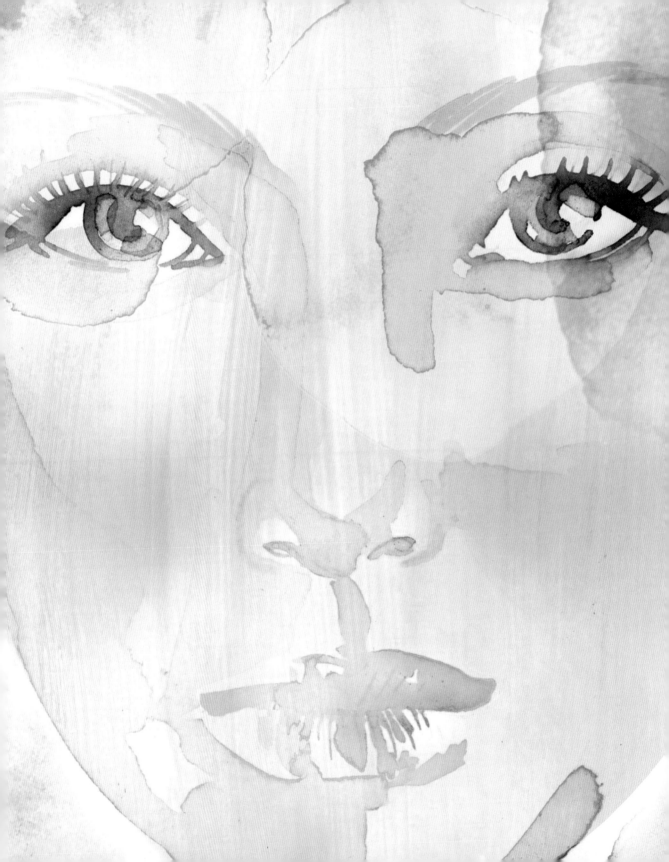

My love is deep;
the more I give to thee,
the more I have,
for both are infinite.

JULIET CAPULET

Romeo and Juliet by William Shakespeare

When we hear voices that we love, we need not understand the words they say.

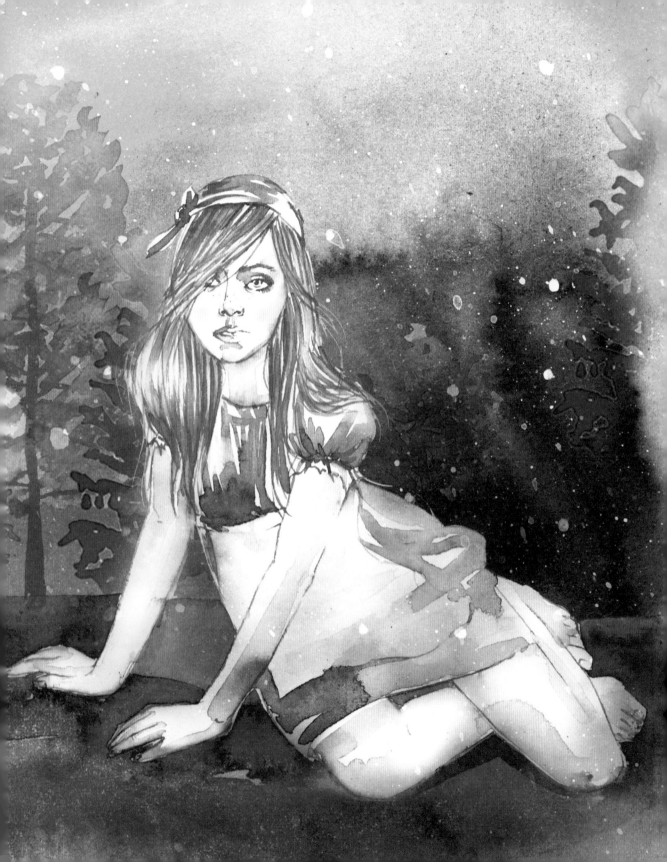

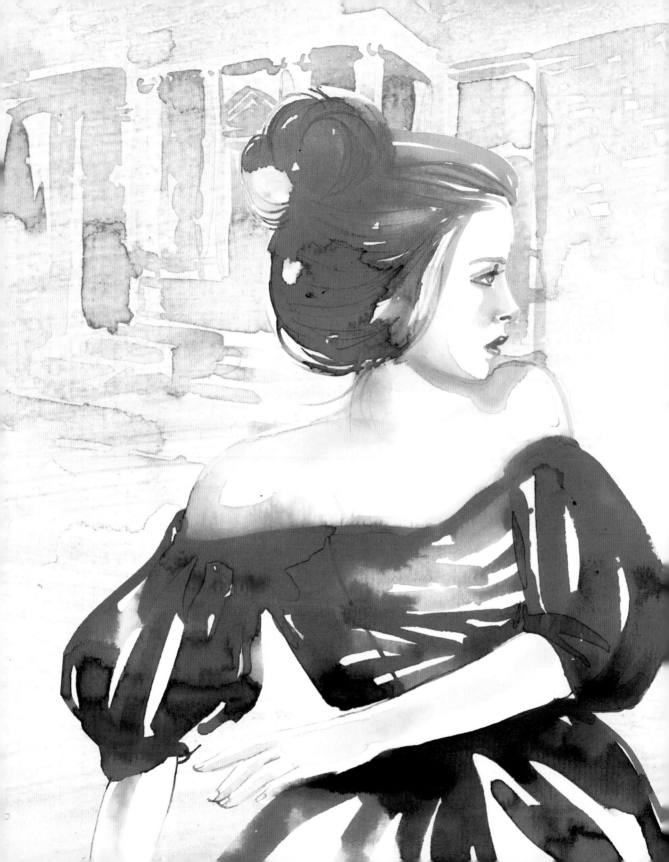

love will carry you all lengths

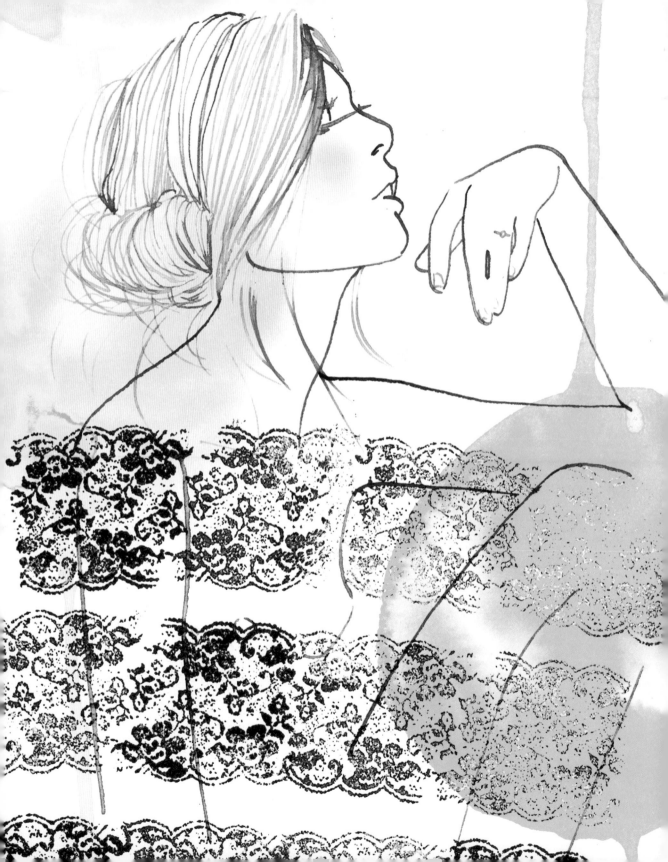

I can do anything to you. Any woman can do anything to you. You're a fool.

CATHY AMES
East of Eden by John Steinbeck

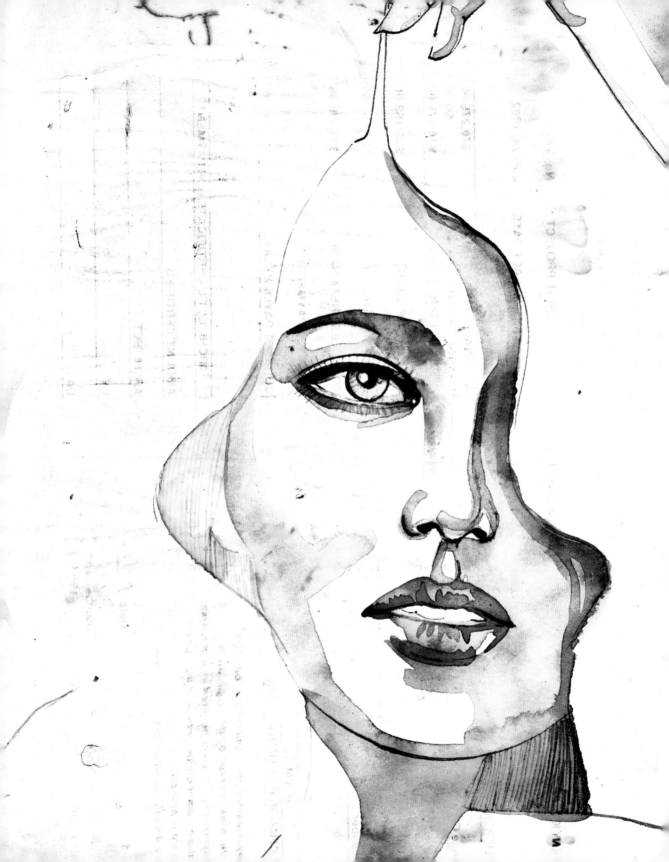

There is something demoralizing about watching two people get more and more crazy about each other, especially when you are the only extra person in the room.

ESTHER GREENWOOD
The Bell Jar by Sylvia Plath

And please tell me what's the matter.

Have I changed?

Am I not the girl you abandoned two months ago?

DAISY CLOVER
Inside Daisy Clover by Gavin Lambert

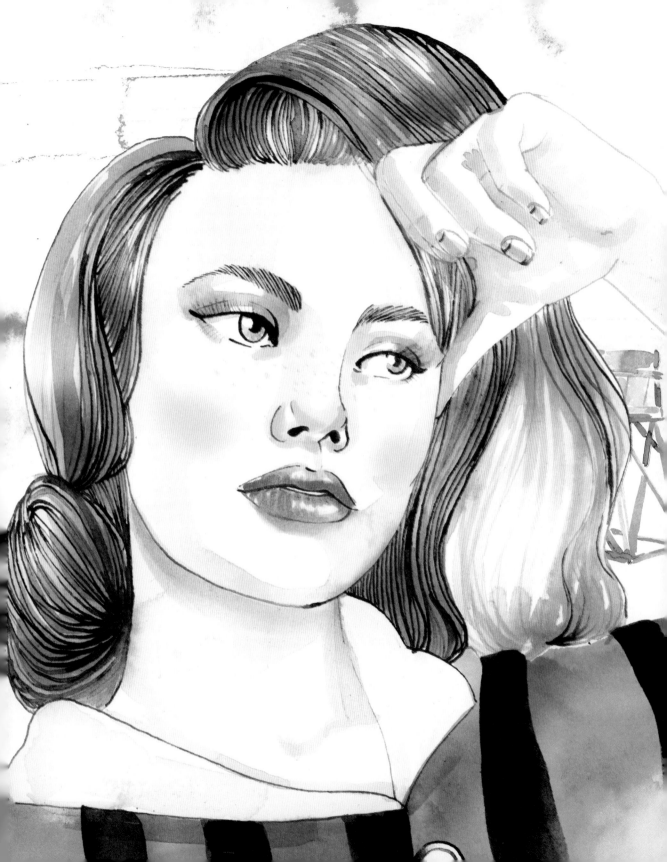

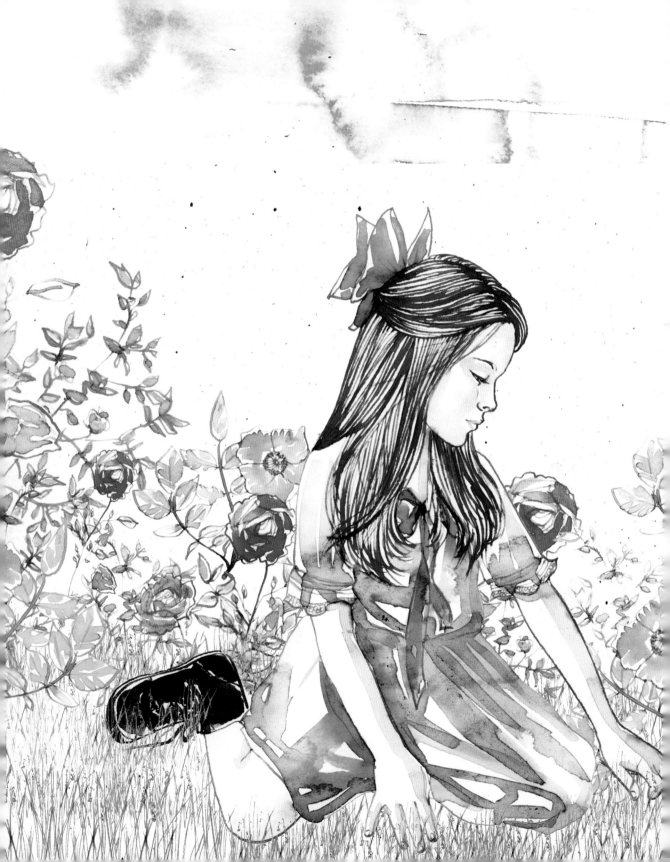

You learn things by saying them over and over

and thinking about them

until they stay in your mind forever.

MARY LENNOX
The Secret Garden by Frances Hodgson Burnett

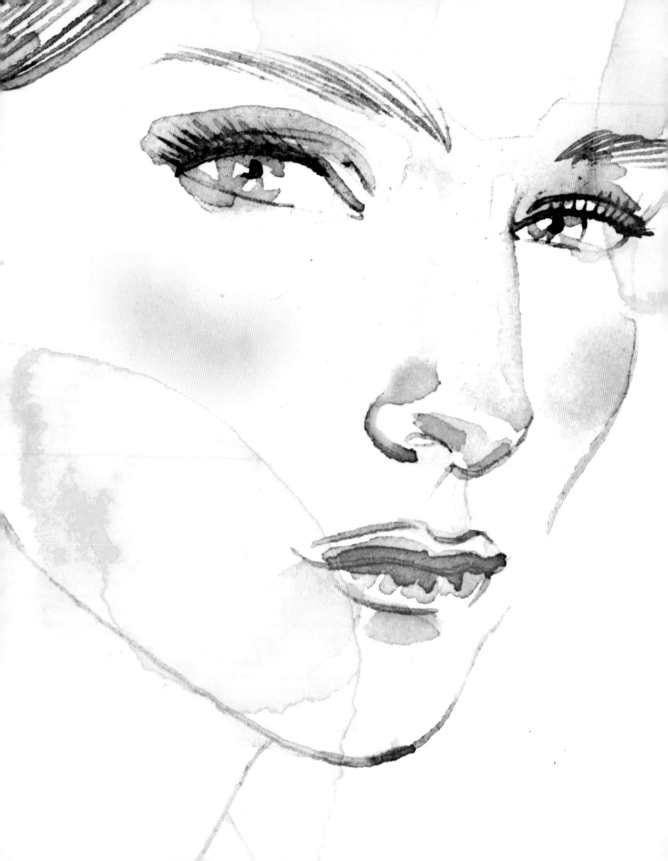

There was a long hard time when I kept far from me, the remembrance of what I had thrown away when I was quite ignorant of its worth.

ESTELLA HAVISHAM
Great Expectations by Charles Dickens

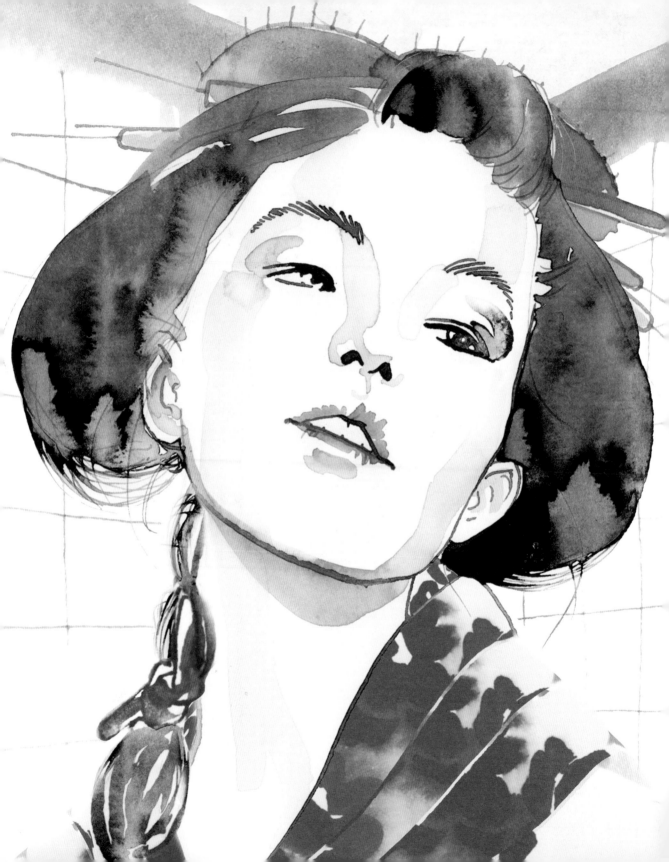

Since my departure for this dark journey,

Makes you so sad and lonely,

Fain would I stay though weak and weary,

And live for your sake only!

LADY KIRI-TSUBO

The Tale of Genji by Murasaki Shikibu

It seems as if I could do anything when I'm in a passion. I get so savage, I could hurt anyone and enjoy it.

Little Women by Louisa May Alcott

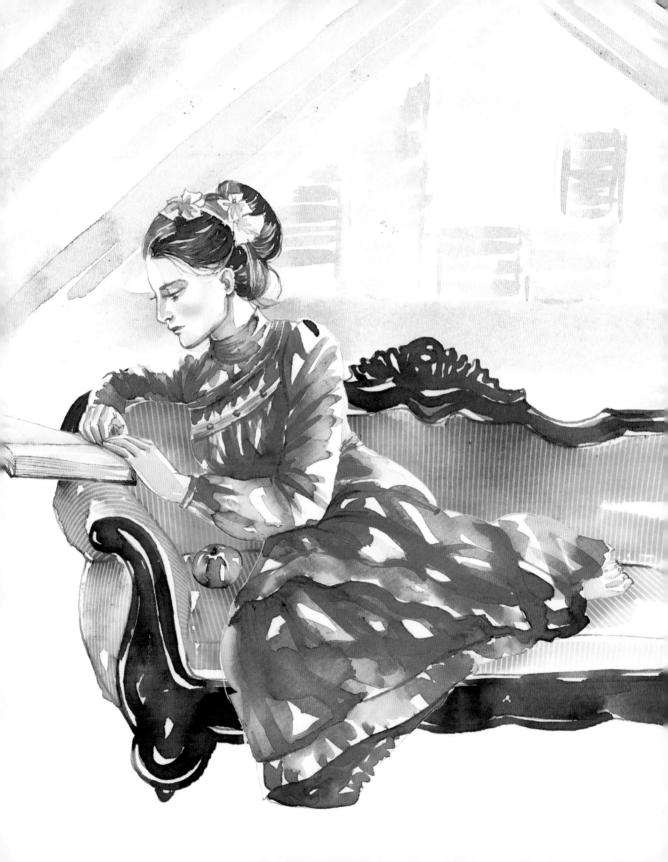

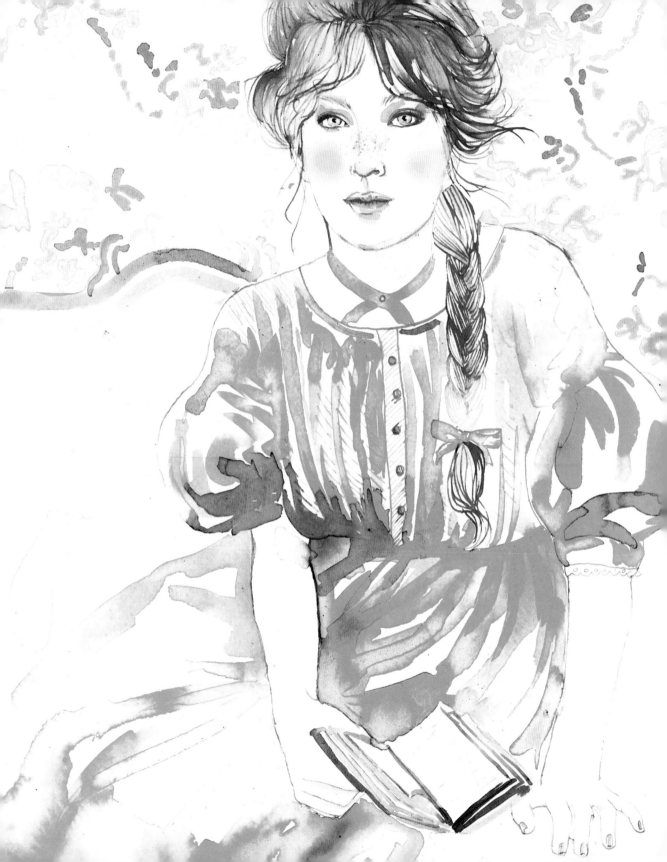

isn't it nice to think
that tomorrow is a new day
with no mistakes in it yet?

ANNE SHIRLEY

Anne of Green Gables by Lucy Maud Montgomery

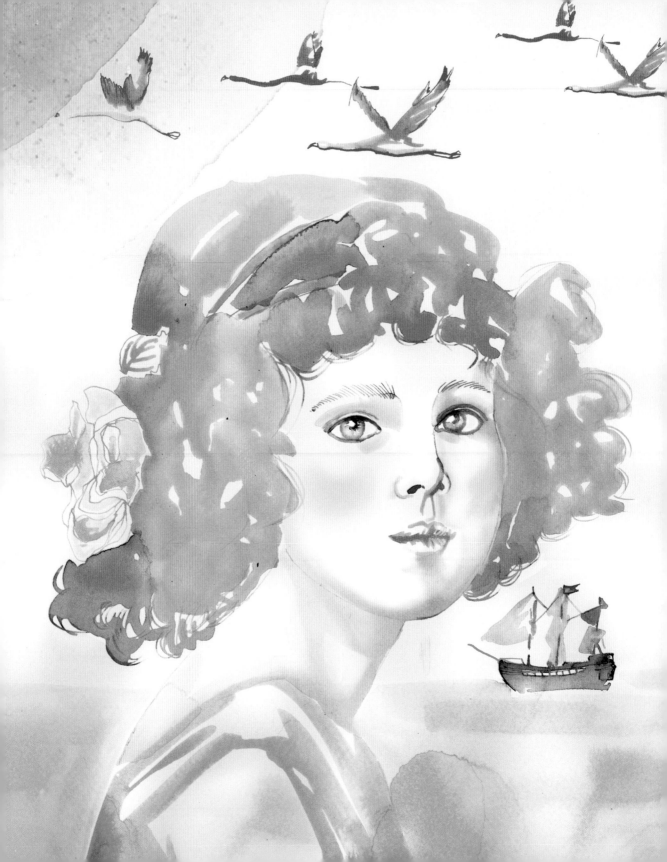

If you knew how great is a mother's love...you would have no fear.

WENDY DARLING

Peter Pan by J.M. Barrie

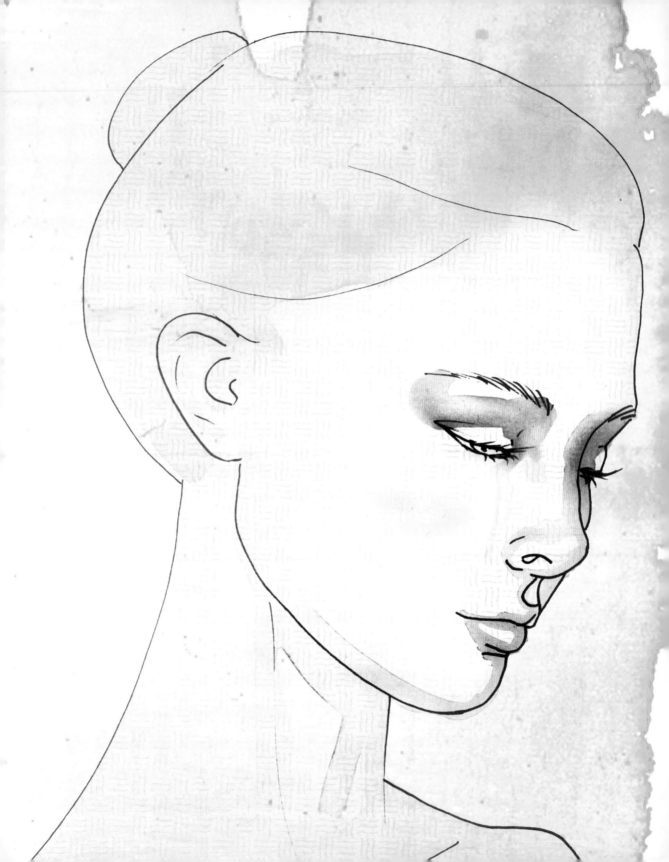

You must accept suffering and redeem yourself by it.

Everything has strings leading to everything else. We're all so tied together.

DOMINIQUE FRANCON
The Fountainhead by Ayn Rand

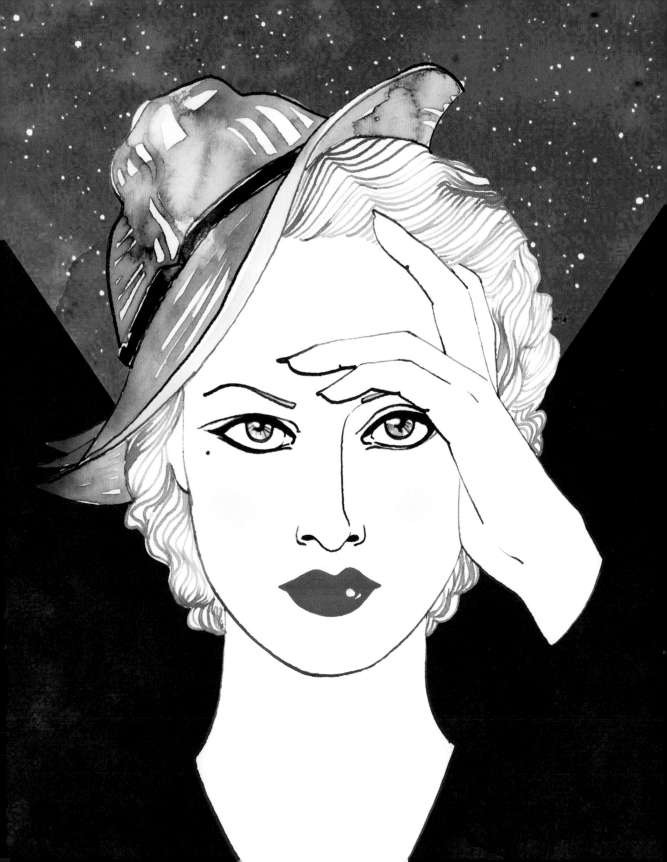

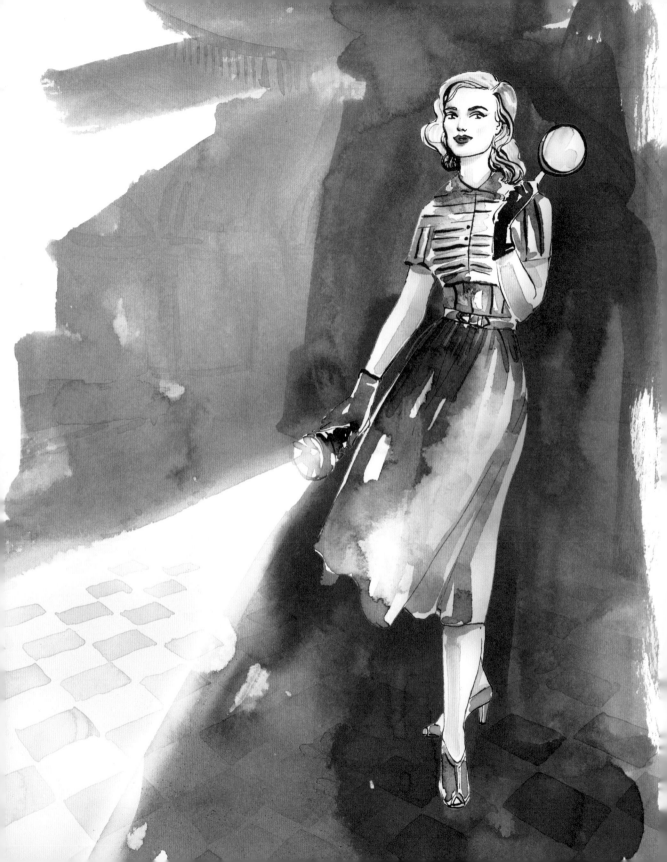

I'll let someone else carry of the social honors ... I'll stick to mystery.

NANCY DREW

The Secret in the Old Attic by Carolyn Keene

What do we live for,
if it is not to make life
less difficult to each other?

DOROTHEA BROOKE
Middlemarch by George Eliot

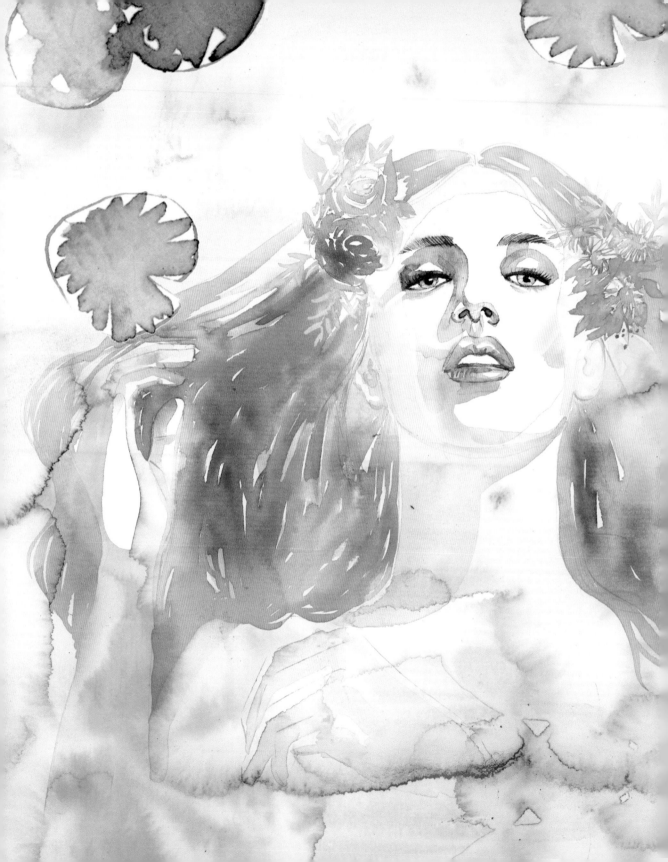

O, woe is me

T have seen what I have seen,

see what I see!

OPHELIA

Hamlet by William Shakespeare

His heart was going like mad

and yes I said yes

I will Yes.

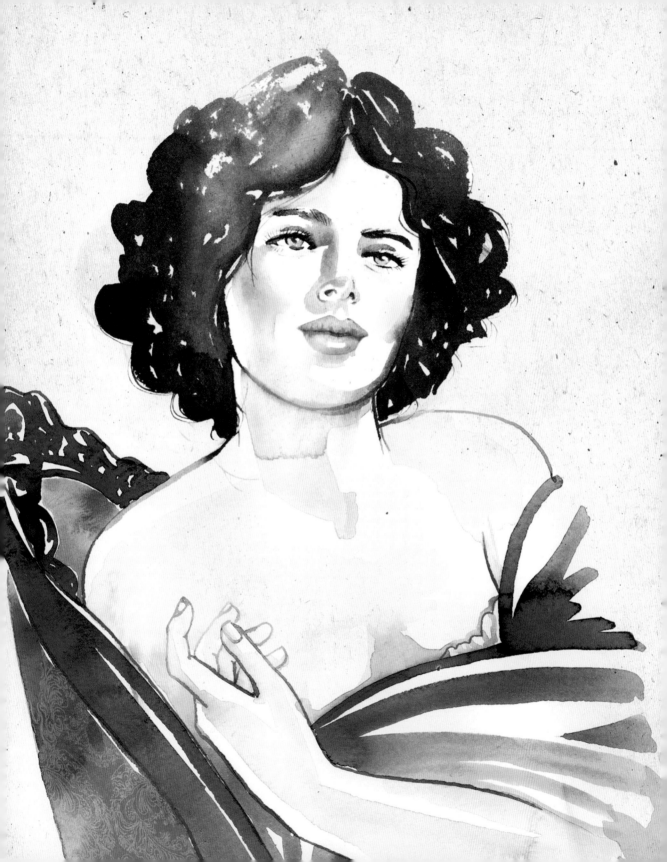

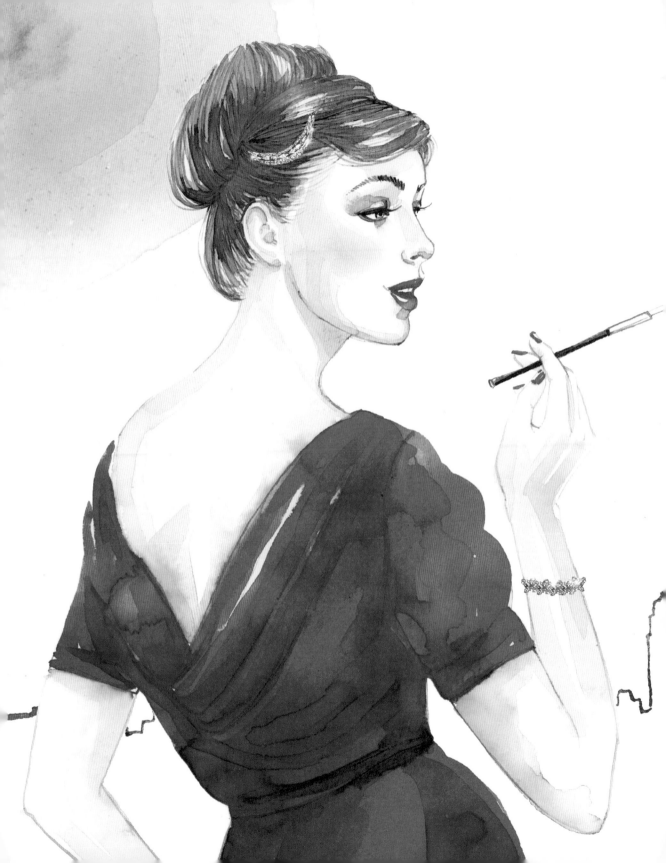

Love should be allowed. I'm all for it.

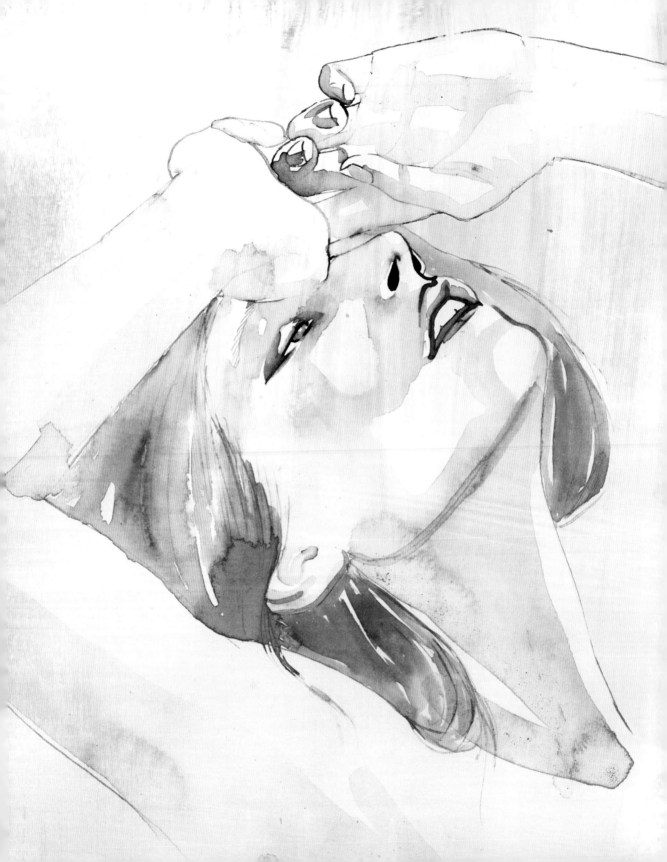

Our souls are knit into one, for all life and all time.

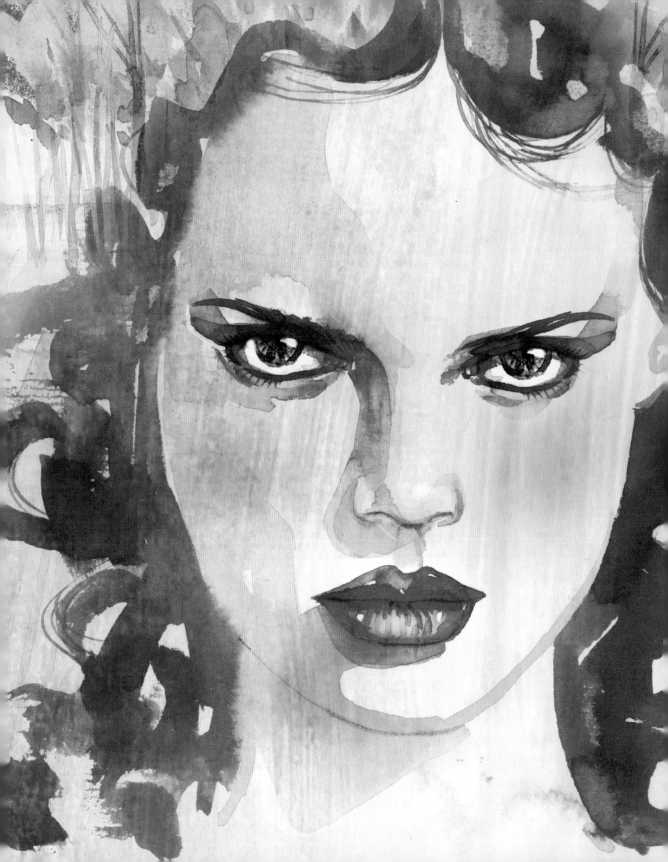

I have courage enough for any danger I can foresee, for every misfortune which I understand.

The Three Musketeers by Alexandre Dumas

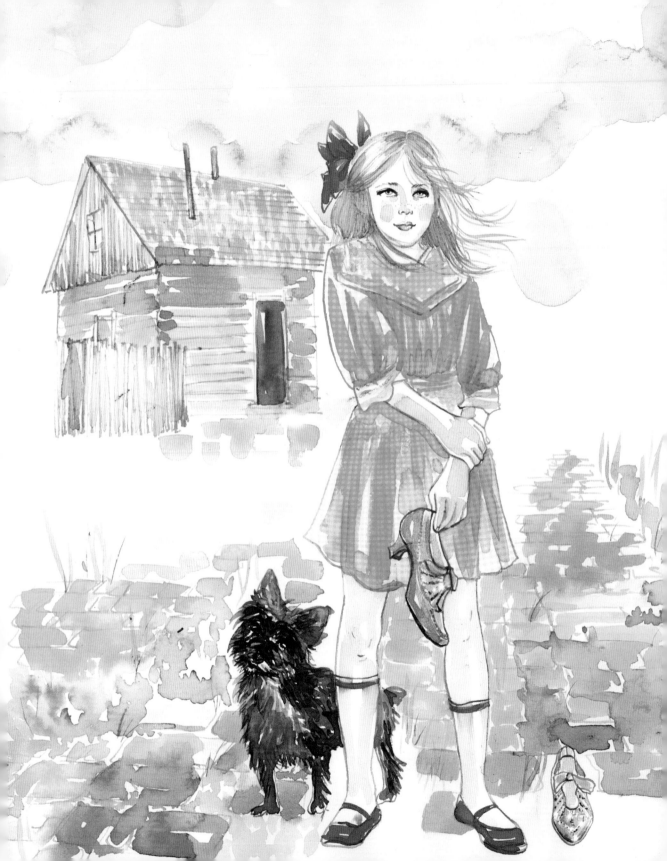

there is no place like home.

A lady's imagination is very rapid; it jumps from admiration to love, from love to matrimony in a moment.

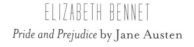

ELIZABETH BENNET

Pride and Prejudice by Jane Austen

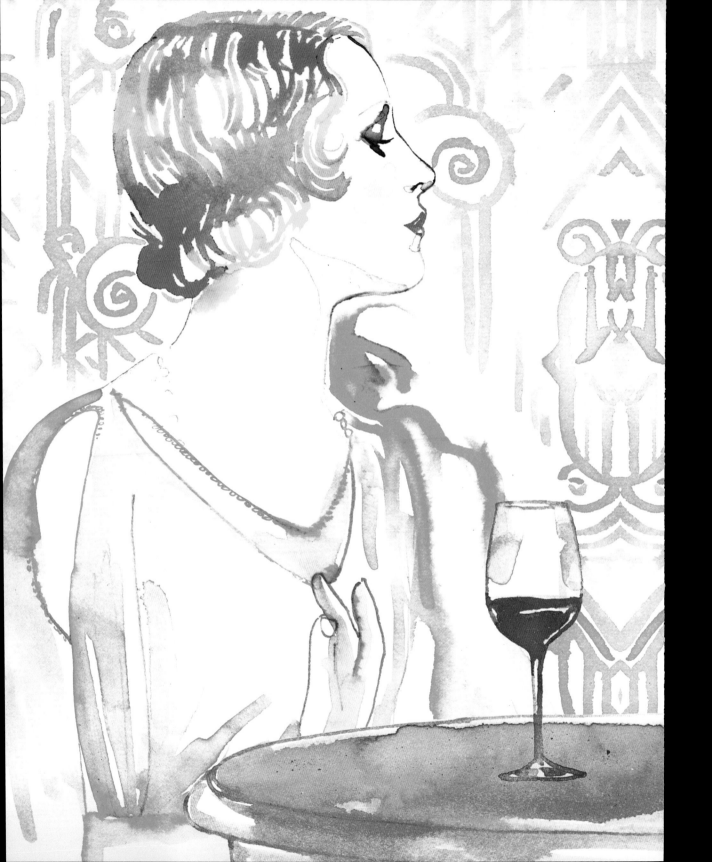

We could have had such a damn good time together.

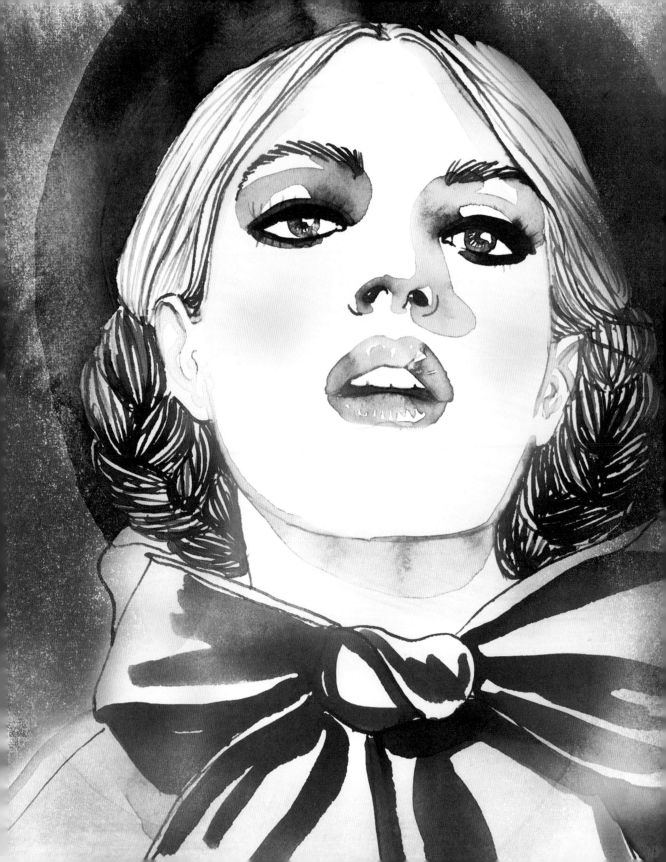

After all, tomorrow is another day.

CREDITS

INDEX

ACKNOWLEDGMENTS

I'll be forever grateful for the love and support of my husband, David, and our son, Henry; my mom, Marika; my team at Chronicle Books including Kate Woodrow, Caitlin Kirkpatrick, and Kristen Hewitt. Thank you sincerely to the lovely models who helped me bring my favorite characters to life: Ella Beesley, Anna Hoffman, Lila Steinhardt, and Caroline Ventura. I'd also like to thank my literary agent Melissa Flashman, my illustration agents CWC-i, Harriet Jung, Abby Clawson Low, and Erin Jang.